Postcards of

Lost Royals

Introduction by
Andrew Roberts

The publisher would like to thank John Pinfold for his generous help in producing this publication.

First published in 2009 by the Bodleian Library
Broad Street
Oxford OX1 3BG

www.bodleianbookshop.co.uk

ISBN: 978 1 85124 332 7

Introduction © Andrew Roberts, 2009
This edition © Bodleian Library, University of Oxford, 2009

Every effort has been made to ascertain copyright and to trace and contact the copyright owners for the postcards where applicable. If such owners make themselves known, a full acknowledgement will be made in future reprints.

Designed by Dot Little
Printed and bound in China by C&C Offset Printing Co. Ltd.
British Library Catalogue in Publishing Data
A CIP record of this publication is available from the British Library

Collector's Foreword

From an early age I was interested in history. My mother gave me my first postcard, of King George VI at his coronation. When she took me to St Paul's Cathedral, I bought a postcard of Nelson's statue. In 1944 my local Woolworths sold sepia photographic postcards of generals Eisenhower, Alexander, and Montgomery. From then on I was a compulsive collector of any postcards of a historical or current political interest.

I was strongly influenced by the example of my artist aunt, Helen McKie (pronounced to rhyme with key). She had a large collection of postcards, mainly of views, arranged in order of country and subject matter, which she used for reference purposes. So I had her example to follow, and after her death I acquired her postcards of Hitler (she was the first woman artist to be allowed in the Brown House when she was commissioned to do a series on Germany in 1932 for the *Sketch*) and also cards of Rome with its Fascist décor. (There is an entry for her in *Who Was Who* for the 1950s.)

John Fraser, London

Introduction

'After this is over, there will only be five kings left in the world,' went the old First World War quip, 'those of hearts, clubs, diamonds, spades, and England.' This splendid collection of postcards featuring the "Lost Royals' of now non-existent thrones, shows how close this came to being true. The two world wars of the twentieth century saw the tumbling of thrones and establishing of republics at a faster rate than ever before in history, as monarchies that often traced their lineages back to the Middle Ages proved incapable of fulfilling the changing expectations of the New World Order.

These postcards come from the astonishingly large and comprehensive collection that was built up over a lifetime by John Fraser and generously donated to the Bodleian Library in Oxford. Presumably originally sent by people who admired the monarchs they feature, the cards now form a fascinating archive of that intimately inter-connected pre-1914 cousinhood that today seems as distant to us as the Napoleonic era.

Here they are, blue-blooded to a man and matriarch, with their good-natured smiles, weak chins, absurd costumes, and baroque names, captured in time and not

knowing—most were taken before 1914—that their world was soon to end in a hecatomb of bloodshed. The royal primarily responsible, Kaiser Wilhelm II of Germany, appears twice, once in the *Unsere Kaiserfamilie* postcard as Emperor, with all his pre-war Hohenzollern arrogance, and then with two of his sons (both of whom he named after himself) in exile at Doorn in Holland, looking prematurely aged and hollow-eyed. The first photograph looks like a declaration of war; the second like an admission of defeat.

What was needed in a monarch was not intellectual capacity so much as a fine character, an instinct for doing one's duty, and the ability to personify the best in a nation, rather as Queen Elizabeth II does for Britain today. These monarchs were not intellectuals; they left that up to men like V. I. Lenin, Leon Trotsky, and Alfred Rosenberg who were to have such a profound and wide-reaching effect on the century thereafter. Yet when we look at the chronic instability of south-eastern Europe even in our own time, with the Bosnian massacres of the 1990s its exemplar, it is hard not to feel nostalgic for those (admittedly somewhat Ruritanian) monarchies that could represent different ethnic groupings without conflict.

As they stand there, sometimes pompously but more often simply dutifully, in their uniforms, high boots, *pickelhaube*, or spiked helmets, epaulettes, swords, sashes, orders, medals, stars, and decorations, they seem to mourn their lost thrones, but so should we. Compared to what came after them, the pre-1914 crowned heads of Europe were a generally benevolent bunch, with the single – but crucial – exception of the deeply psychologically flawed Kaiser Wilhelm II.

Two of the people from his collection who are still alive give credence to the notion of the European royals being a 'Good Thing'. Prince Michael of Romania returned to his country after the collapse of Communism and has played a genuinely positive role in its rejuvenation. He was not given his throne back, but he exercised considerable influence for the good, successfully lobbying for Romania to be allowed to join NATO and the European Union.

Similarly, Archduke Otto von Habsburg—who was christened Archduke Franz Joseph Otto Robert Maria Anton Karl Max Heinrich Sixtus Xaver Felix Renatus Ludwig Gaetan Pius Ignatius of Austria—the sad-looking blond boy seen sitting on the lap of his father, the last

Emperor of Austria Carl I, has dedicated his life to the lands he was born to inherit but never did due to the Great War. A former MEP and President of the Paneuropean Union, he has been another force for good in modern Central Europe.

As these doomed royals stare out at us from across a blood-stained century, wearing their sailor suits, dinner jackets, uniforms, and, in the case of the magnificent Jam of Nawanagar, a bejewelled turban, they betray no sense that their titanic, utterly confident world was heading directly for the iceberg of the Great War. Names like Mecklenburg-Strelitz, Sachsen-Altenburg, and Saxe-Coburg-Gotha are all represented here, but are about to march off into history. The hussar uniform worn by Prince Ernst August and the splendid white moustache sported by King Peter of Serbia might look like something straight out of the Anthony Hope novel *The Prisoner of Zenda*, but they were part of the romance and magic of monarchy, which was all too soon to disappear in the abattoir of 1914–18.

The spark of the conflagration was provided by the assassination of two of the people pictured here, the Archduke Franz Ferdinand of Austria and his (morganatic)

wife Sophie. It was indeed a malign destiny that placed the terrorist Gavrilo Princip directly outside Moritz Schiller's delicatessen on the riverside road in the Sarajevo city centre on 28 June 1914, only six feet away from where the Archduke's Graf and Stift open-topped car momentarily stopped in order to change gear into reverse, because the chauffeur had taken a wrong turning. (You can see the car today, complete with bullet holes, in the Heeresgeschichtliches Museum in Vienna, along with a gun said to be the one used.) Princip fired twice, killing both passengers. 'Sophie! Sophie! Don't die,' were Franz Ferdinand's anguished last words, 'Live for our children.' The postcard also shows the young Sophie, Maximilian and Ernest, the first of millions of children to be orphaned in the subsequent war.

This collection also features Queen Victoria with her great-grandson Prince Edward—known to the family as David and to history as Edward VIII and latterly as the Duke of Windsor. 'Granny and the Baby' is the caption, and in a sense the Queen-Empress was indeed the grandmother of Europe, so many royal lines were attached to hers. This postcard also shows how even the British royal family was not immune to having 'Lost Royals', because Edward VIII abdicated in December 1936. Unlike Michael of Romania, Edward did not have a revolver held to his head by a Communist revolutionary; instead he fell in love.

Andrew Roberts

The Postcards

8

Queen Victoria (1819–1901, reigned 1837–1901) and Edward VIII (1894–1972, reigned 1936)

The future King Edward VIII and Duke of Windsor is here pictured with his great-grandmother Queen Victoria. Superficially glamorous and attractive, he was a popular Prince of Wales, but his father, George V, had a better understanding of his character. He told the prime minister, Stanley Baldwin, 'After I am dead, the boy will ruin himself in twelve months,' a prediction which proved to be remarkably accurate. Succeeding to the throne in January 1936, Edward abdicated in December, following the refusal of the government to allow him to marry Wallis Simpson, an American divorcée.

In 1937 the Duke and Duchess of Windsor visited Germany to meet Hitler, and subsequently the Duke was never able to throw off accusations of being pro-Nazi. At the beginning of the Second World War, he was attached to the British Military Mission in France, but when the Germans invaded he deserted his post and fled to neutral Spain and then to Portugal. Churchill threatened him with a court martial if he did not return to Britain and then despatched him to the Bahamas as Governor, a post he held until the end of the war.

Following the Second World War, the Duke and Duchess lived in Paris, where they were exempted from paying income tax by the French government. Prominent members of café society in the immediate post-war period, they came to appear increasingly pathetic figures as they grew older. After the Duke died in 1972, his body was brought back to England, and he is buried in the royal burial ground at Frogmore. The Duchess died in 1986 and is also buried at Frogmore.

GRANNY AND THE BABY.
HER LATE MAJESTY QUEEN VICTORIA & PRINCE EDWARD.

J. BEAGLES & CO

531 C MATT.
G.531 C GLOSSY.

Hughes & Mullins, Ryde.

Napoleon III, Emperor of the French (1808–1873, reigned 1852–1871)

The nephew of Napoleon I, Louis Napoleon spent his early life in exile in Switzerland and Germany. He staged a number of abortive coups to gain power in France, which led to his imprisonment. After escaping to England, he returned to France during the revolution of 1848 and was elected to the National Assembly. He became President of the Second Republic, but in 1851 staged a coup and made himself dictator; the following year he declared himself Emperor of the French and inaugurated the Second Empire.

Aiming to re-establish France as the leading European power, he involved his country in a number of foreign wars, and supported the Italians in achieving unity through expelling Austria from her Italian provinces. However, his attempt to install Maximilian as Emperor of Mexico ended in disastrous failure.

At home Napoleon promoted liberal policies and his reign saw the rebuilding of Paris in Beaux-Arts style under the direction of Baron Haussmann.

In 1870 Napoleon was outwitted by Bismarck and drawn into the disastrous Franco-Prussian War. After the defeat at Sedan, he was forced to abdicate and fled to England, where he spent the last two years of his life in Chislehurst. He is buried at St Michael's Abbey in Farnborough, which was constructed as an imperial basilica under the instructions of his widow, the Empress Eugénie.

Nicholas II, Emperor of All the Russias (1868–1918, reigned 1894–1917) and the Tsarevich Alexei (1904–1918)

Weak, vacillating, determined to maintain the autocratic style of government but without a clear political programme of his own, Nicholas might still have retained his throne had he not led Russia into the First World War. Military failure, allied to increasing chaos and food shortages on the home front led to a rapid haemorrhaging of support for the regime, and by the spring of 1917 Nicholas had lost the support of the army commanders, the political classes, and the general populace alike. The unpopularity of the 'German' Empress Alexandra and her reliance on Rasputin reduced support for the monarchy still further. Ill-informed and isolated at the army headquarters at Mogilev, Nicholas was given no choice but to abdicate after the outbreak of the February Revolution.

The Tsarevich was the only son of Nicholas and Alexandra. He suffered from the hereditary disease of haemophilia, and it was Rasputin's supposed ability to cure this disease that led to his increasing influence over the royal family, who were in any case strongly attracted to mysticism and populism.

After his abdication, there was a possibility of the Tsar being offered asylum in England, but although the British government was prepared to support this, Nicholas's cousin, King George V, vetoed the idea. Nicholas, his wife, and his children were all murdered in the Ipatiev House at Ekaterinburg on 17 July 1918 by local Bolsheviks acting on Lenin's orders.

The graves of the Russian royal family were excavated in 1991 and the remains were subsequently reburied in the Peter and Paul Cathedral in St Petersburg. Nicholas was canonized by the Russian Orthodox Church as a 'passion bearer', and in present-day Russia he is often referred to as Nicholas the Martyr rather than the Nicholas the Bloody of previous times.

281.L. H.I.M. CZAR, & CZAREVITCH OF RUSSIA. SOISSONNAS
BEAGLES POSTCARDS. & EGGLER

13

Grand Duchess Anastasia of Russia (1901–1918)

The youngest of the Tsar's daughters, Anastasia was lively and vivacious, had a talent for amateur dramatics, and reportedly had a laugh 'like a squirrel'. Too young to serve as a nurse during the First World War, as her older sisters did, she nevertheless visited wounded soldiers at Tsarskoye Selo and attempted to raise their morale.

After the February Revolution in 1917, she, like the rest of the Russian royal family, was placed under house arrest. Moved first to Tobolsk and then to Ekaterinburg, she was murdered with the rest of the family by local Bolsheviks, acting on the orders of Lenin, on 17 July 1918.

J. BEAGLES & Co., Ltd., Printers & Publishers, E.C.

Photo in I L N of 12 Nov. 1910.

POST CARD

For Correspondence

For Address Only

BEST IN THE WORLD

Printed in England by J. Beagles & Co. Ltd. London, E.C.

For much of the rest of the twentieth century there were persistent rumours that Anastasia had survived the massacre at Ekaterinburg. Several women claimed to be Anastasia, of whom the most intriguing was Anna Anderson, who maintained her claim from the 1920s until she died in 1984. Accepted by some who had known the real Anastasia, she was never accepted by the senior surviving Romanovs, and DNA tests have since proved that her claim was false.

When the graves of the Russian royal family were excavated in 1991, it was found that two sets of bones were missing, prompting further suggestions that Anastasia had survived, but in 2007 two further sets of remains were found and DNA tests have proved that all members of the family were indeed executed in 1918.

281 E BEAGLES' POSTCARDS

GRAND DUCHESS ANASTASIA OF RUSSIA
FOURTH DAUGHTER OF THE TSAR.

E.N.A

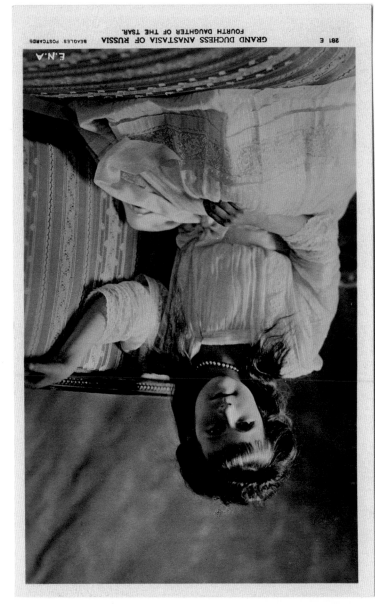

The German royal family

It is interesting that this postcard of the German royal family in all their pomp, with the Kaiser and the Crown Prince at the centre, should have been posted in 1919, shortly after the abdication of the Kaiser and the abolition of the monarchy.

The Hohenzollern family originated in Swabia in the eleventh century and became a dynasty of, successively,

Electors of Brandenburg, Kings of Prussia, and German Emperors. However, the current head of the family, Prince Georg Friedrich, has declared that he is content to be a private citizen in the Federal Republic of Germany, and has been quoted as saying that he is 'probably happier than many of my forebears'.

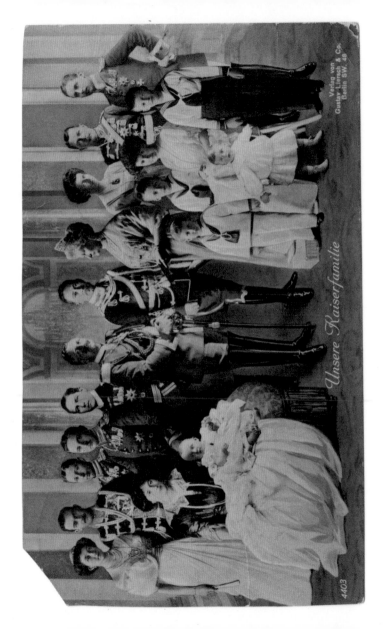

Unsere Kaiserfamilie

Verlag von
Gustav Liersch & Co.
Berlin SW. 48

4403

Aufnahme von E. Steiner, Hoffphotogr. Moers u. Kleve 1027 No. 12

Wilhelm II, German Emperor (1859–1941, reigned 1888–1918), Crown Prince Wilhelm (1882–1951) and Prince Wilhelm (1906–1940)

Three generations of the Hohenzollern dynasty, pictured after the First World War. The oldest grandson of Queen Victoria, Wilhelm II was the last German Emperor and King of Prussia, being forced to abdicate at the end of the First World War. To what degree he bore responsibility for the war remains a matter of debate. In Churchill's memorable phrase, 'Underneath all [his] posing and its

trappings was a very ordinary, vain, but on the whole well-meaning man, hoping to pass himself off as a second Frederick the Great.' In November 1918 he fled to the Netherlands, where he lived in retirement at the castle of Doorn until his death.

Crown Prince Wilhelm, contemptuously referred to as 'Little Willy' by the English during the First World War, was brought up to serve in the army, and in 1914 he was appointed to command the Fifth Army, which took part in the battle for Verdun, an action the Crown Prince came to disapprove of. Unlike his father, the Crown Prince did not remain in exile after the fall of the monarchy in 1918 but returned to Germany. He flirted with groups that were close to the Nazis, but took no further part in politics after the Night of the Long Knives in 1934. He did not serve during the Second World War and died on his estates in Swabia in 1951.

Prince Wilhelm renounced his rights to the throne in 1933 when he married Dorothea von Salviati, whom he had met whilst a student at the University of Bonn, and his grandfather refused to sanction the match. At the beginning of the Second World War he joined the German army and was killed during the invasion of France in May 1940. His funeral drew such large crowds of mourners that Hitler forbade any other members of the German royal house from serving in the military.

phot. Steiger

Kaiser Wilhelm II
Kronprinz Wilhelm, Prinz Wilhelm

Crown Prince Wilhelm and his family

The German Crown Prince married Cecilie of Mecklenburg-Schwerin (1886–1954) in 1906. The couple had six children, the first five of whom are shown on this card, which dates from 1915.

Their second son, Prince Louis Ferdinand (1907–94), opposed the Nazis and was interrogated by the Gestapo after the plot to kill Hitler in 1944. Prince Georg

Friedrich, the current head of the house of Hohenzollern, is his grandson.

The Crown Prince and his family lived at the Cecilienhof Palace at Potsdam, a mock-Tudor mansion which was based on Bidston Court on the Wirral peninsula. It was later used as the venue for the Potsdam Conference at the end of the Second World War.

Die kronprinzliche Familie.

7517
Verlag von
GUSTAV LIERSCH & Co.
BERLIN S.W.

Original-Aufnahme
von W. Niederastroth, Kgl.Hofphotograph
Potsdam.

Wilhelm II, King of Württemberg (1848–1921, reigned 1891–1918)

The fourth and last king of Württemberg, Wilhelm II was a popular and unassuming monarch of liberal tendencies. He deplored the militarism of Kaiser Wilhelm II and was deeply saddened by the outbreak of the First World War. Nevertheless, for reasons of patriotism he felt obliged to give his support to the army during the war, and lost his throne during the revolutionary outbreaks that occurred all over Germany in November 1918. He renounced the throne on 30 November 1918 and went into retirement in the castle of Bebenhausen, where he died in 1921.

Wilhelm II enjoyed meeting his subjects of all classes. He would often take his dogs for walks around Stuttgart and be greeted by them with the words, 'Hello, Mr King', whilst children would often ask him for sweets. He is still held in affection in Stuttgart, where in 1991 a statue of him out walking with his dogs was erected at the Königspassage, outside the former royal palace.

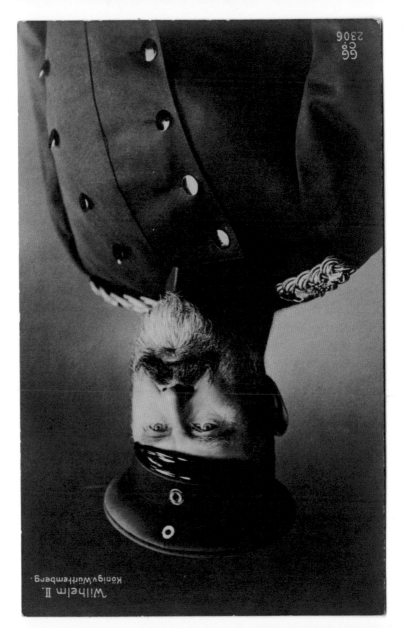

Wilhelm II.
KönigvWürttemberg.

66
23
2306

Prince Rupprecht of Bavaria (1869-1955)

Prince Rupprecht was the last Crown Prince of Bavaria. He was also, after the death of his mother in 1919, the Jacobite heir to the British crown.

The son of Ludwig III, the last King of Bavaria, Rupprecht followed a military career. At the outbreak of the First World War he was appointed commander of the German Sixth Army in Lorraine. Unlike many other royal generals, he proved to be an able commander and in 1916 he was promoted to Field Marshal and given command over a group of four armies on the Western Front. By the end of 1917

Printed in Germany

he realized that the war could not be won but his sense of honour forbade him to resign his command. Eventually he resigned on 11 November 1918, at the same time as revolution in Bavaria was ending the monarchy there.

In the interwar period Rupprecht remained opposed to the Weimar Republic, but hoped to see a constitutional monarchy established in Bavaria. At one point in 1932 there was a plan to give him political power in Bavaria, but opposition from both left and right prevented this from happening.

Rupprecht had no sympathy for the Nazis and from 1939 to 1945 lived in exile in Italy. However, his second wife and their children were captured in Hungary by the Nazis and ended the war in the concentration camp at Dachau. At the end of the war Rupprecht returned to Bavaria, where he hoped to see the monarchy restored. There was clear popular support for this, but the occupying Americans were less sympathetic. He died in 1955 at Schloss Leutstetten and was given a state funeral, being buried in the Theatinerkirche in Munich, near to other members of the Wittelsbach family.

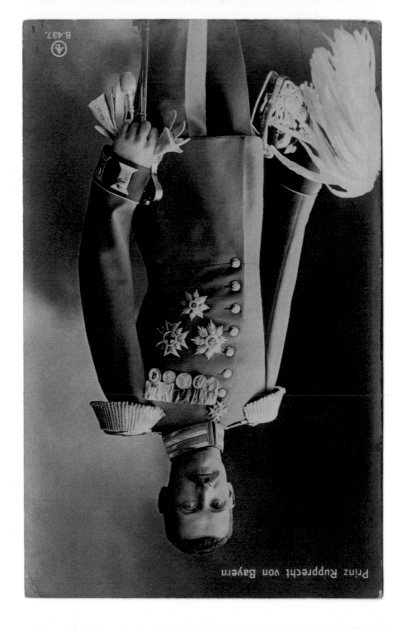

Prinz Rupprecht von Bayern

B.437.

Georg, Crown Prince of Saxony (1893-1943)

Postkarte — Carte postale — Postcard

Printed in Germany.

Georg was the last Crown Prince of Saxony, being heir to his father, King Frederick Augustus III, when the monarchy was abolished in November 1918. In 1923 he renounced his rights to the Saxon throne and became a Jesuit priest, known as Father George.

He worked in Berlin, where it is said he was instrumental in saving a number of Jews from the Nazis. He died in

1943 whilst swimming in the Gross-Glienicke lake in Berlin. Accusations that the Nazis were responsible have never been substantiated.

He is shown here with two of his brothers, Ernst Heinrich (1896–1971) and Friedrich Christian (1893–1968). In 1932 there was a possibility that Friedrich Christian would be offered the crown of Poland but nothing came of this.

3405.

Nicholas, Grand Duke of Oldenburg (1897–1970)

The Grand Ducal state of Oldenburg is included in the present-day German state of Lower Saxony. A relatively liberal state, it became part of the German Empire in 1871.

Nicholas's father, Friedrich Augustus II, was the last reigning Grand Duke of Oldenburg, abdicating in 1918

when the German monarchies were abolished. In 1931 Nicholas inherited the title, despite the passing of a law in 1904 which vested the succession in Friedrich Ferdinand, Duke of Schleswig-Holstein-Sonderburg-Glücksburg.

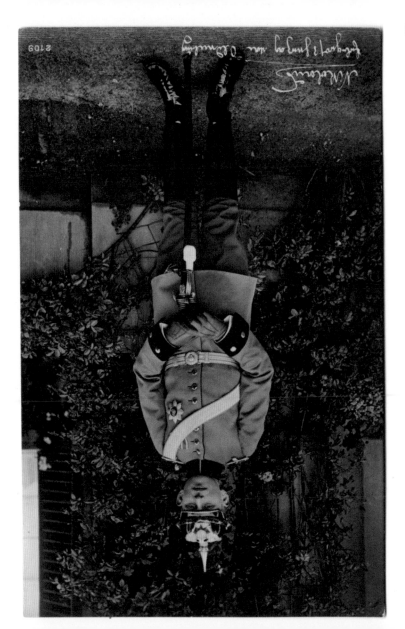

Friedrich Franz IV, Grand Duke of Mecklenburg-Schwerin (1882–1945, ruled 1887–1918)

Mecklenburg-Schwerin was a duchy in the north of Germany that was formed by a partition of Mecklenburg. It now forms part of the German state of Mecklenburg-Vorpommern.

Friedrich Franz IV ascended the throne when he was only five and there was a regency until 1901. In February 1918 he himself also became regent of Mecklenburg-Strelitz after the suicide of the last Grand Duke, but in November 1918, along with the other German princes, he was forced to abdicate. He died in 1945 at Flensburg.

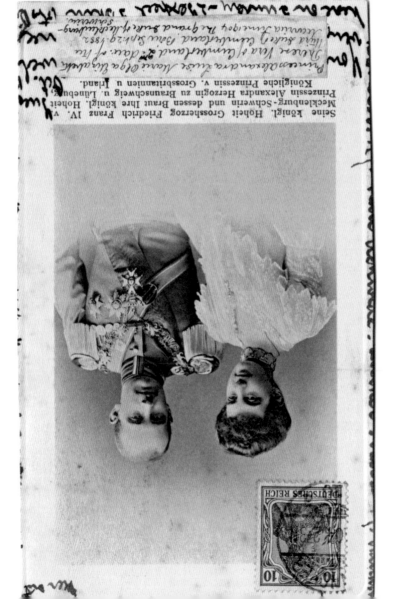

Seine königl. Hoheit Grossherzog Friedrich Franz IV. v. Mecklenburg-Schwerin und dessen Braut Ihre königl. Hoheit Prinzessin Alexandra Herzogin zu Braunschweig u. Lüneburg, Königliche Prinzessin v. Grossbritannien u. Irland.

Elisabeth, Grand Duchess of Mecklenburg-Strelitz (1857–1933)

Princess Elisabeth Marie Frederica Amelia Agnes was the daughter of Friedrich I, Duke of Anhalt. In 1877 she married Grand Duke Adolf Friedrich of Mecklenburg-Strelitz; her mother-in-law wrote:

She welters in happiness at her luxurious Schloss, wearing a new Paris dress daily,

diamonds also when we are quite entre nous. Yes, she does enjoy being a *Grand Duchess!* poor dear: I am glad she does as I never did.

Her son, the last Grand Duke, Adolf Friedrich VI, would have preferred to devote his life to painting, and committed suicide in February 1918.

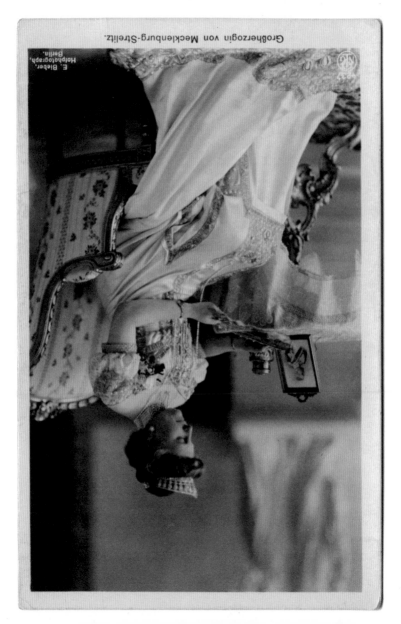

Großherzogin von Mecklenburg-Strelitz.

E. Bieber,
Hofphotograph,
Berlin.

Ernst II, Duke of Sachsen-Altenburg (1871–1955, ruled 1908–1918)

Verlag: L. Henkes Nachf., Altenburg Nr. 743

Sachsen-Altenburg was a German duchy in the present-day state of Thuringia. Ernst II succeeded his uncle as ruler in 1908. He pursued a military career and served as a member of the German General Staff from 1903 to 1905. In the First World War he served on the Western Front and was promoted to General in 1914. However, following an attack of dysentery in 1916, he resigned from active duty.

During the revolution in Germany in November 1918, Ernst attempted to stave off the inevitable by appointing three Social Democrats to his government. However, this was not enough to save him and he abdicated on 13 November 1918. During the interwar years he was able to indulge his scientific interests by studying at the universities of Berlin and Jena. He also joined the Nazi Party in 1935.

At the end of the Second World War Altenburg lay in the Soviet zone of occupation, but Ernst was permitted to continue living at his castle there. He was the only former ruling German prince to become a citizen of the GDR.

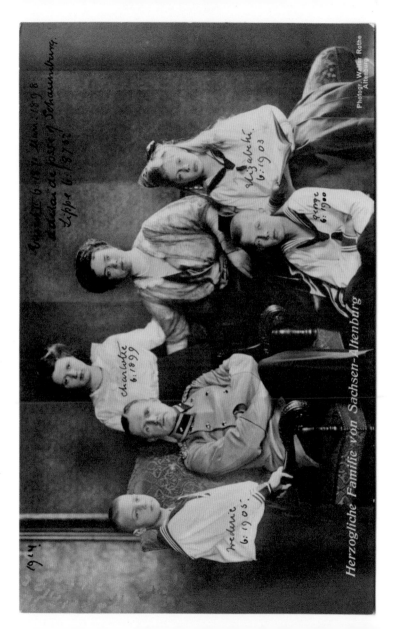

35

1914.

Ernst II. b. 1871 2 un. 1898
Adelheid de Jose y Schaumburg.
Lippe b. 13/43

friedrich
b. 1905.

charlotte
b. 1899

elizabeth.
b. 1903

georg.
b. 1900

Herzogliche Familie von Sachsen-Altenburg

Photogr. Walter Rothe
Altenburg

Georg Donatus, Grand Duke of Hesse and by Rhine (1906–1937)

At the time of this photograph Georg was seven years old, the First World War was still a year away, and the future of the German princely states must have seemed secure. By the time he inherited the title from his father in 1937, the German monarchies had been abolished and the Nazis were in power.

A few weeks after inheriting the title, Georg Donatus, his wife, and three of their four children were killed in an air crash near Ostend, whilst travelling to Britain for the marriage of his younger brother, Prince Ludwig. His youngest daughter, Johanna, was not on the plane, but died of meningitis two years later.

Wohlfahrts-Postkarte
zum Besten des Alice-Frauen-Vereins für
Krankenpflege im Großherzogtum Hessen

Verband Deutscher Papier- und Schreibwarenhändler
Ortsgruppe Darmstadt

Georg, Erbgroßherzog von Hessen

Erwin Raupp

Darmstadt

Ludwig, Prince of Hesse and by Rhine (1908–1968)

Ludwig was the younger brother of Grand Duke Georg Donatus, and inherited the title on the latter's death in a plane crash in 1937. His marriage to Margaret Cambell-Geddes, to which his brother had been travelling at the time of the crash, took place the following day. The couple had no children, and at his death the title went to his distant cousin, Moritz, Landgrave of Hesse.

Ludwig was a composer of music of some note, and was a friend of Benjamin Britten and Peter Pears. Both he and his wife were important patrons of the arts in Germany and Britain. Margaret became President of the Aldeburgh Festival and established the 'Hesse Students' scheme to enable young people to attend the Aldeburgh Festival in return for practical help.

Erwin Raupp Darmstadt

Ludwig, Prinz von Hessen

Karoline Mathilde, Duchess of Holstein-Glücksburg (1860–1932)

Princess Karoline Mathilde Schleswig-Holstein-Sonderburg-Augustenburg was the second daughter of Frederick VIII, Duke of Schleswig-Holstein. Her older sister Augusta Viktoria later married Wilhelm II of Germany and thus became German Empress and Queen of Prussia. When Karoline Mathilde was only four years old one of Bismarck's wars led to Schleswig-Holstein being detached from Denmark and being incorporated into the German Empire.

She married Friedrich Ferdinand of Schleswig-Holstein-Sonderburg-Glücksburg in 1885. Her son later became Duke of Schleswig-Holstein.

She died in 1932 at Grünholz in Schleswig-Holstein.

Herzogin Karoline Mathilde
von Holstein-Glücksburg

Caroline Matilda of Slesvig
Holstein Born 1860 Maii 1885
Duke Frederic of Slesvig Holstein
(brother of the Duchess of Saxe
Coburg)

A. Gimm, Gotha 1906

41

Victoria Adelheid, Duchess of Saxe-Coburg-Gotha (1885–1970)

Princess Victoria Adelheid was the daughter of Friedrich Ferdinand, Duke of Schleswig-Holstein-Sonderburg-Glücksburg. In 1905 she married Charles Edward, the Duke of Saxe-Coburg-Gotha, the son of the Duke of Albany and grandson of Queen Victoria.

Her husband's career was a controversial one. In the First World War he decided to side with Germany and was stripped of his British titles and his membership of the Order of the Garter. Like the other German royal princes he was forced to abdicate in November 1918,

and then drifted into right-wing politics. He joined the Nazi Party and was a member of the SA (Brownshirts). In 1936 he visited Britain in an attempt to improve Anglo-German relations, which came to nothing. He also served as President of the German Red Cross and it has been suggested that in this capacity he must have been aware of the ethnic cleansing carried out by the Nazis in the occupied territories of eastern Europe. In 1946 he was arrested by the Americans and sentenced by a denazification court. He died in poverty in 1954, but his wife lived on in Austria, not dying until 1970.

1919.

Herzogin Victoria Adelheid
von Sachsen-Coburg u. -Gotha mit ihren Kindern.

B. 1909

B. 1908.

B. 1912.

B. 1906.

Orig.-Aufn. v. B. Münchs,
Hofphot., Gotha

1127

Kunstverlag A. Gimm,
Gotha

43

Prince Christian of Schleswig-Holstein (1831–1917)

Prince Christian was the second son of Christian August, Duke of Schleswig-Holstein-Sonderburg-Augustenburg. As a young man he briefly saw military action, fighting against Danish forces in the war of 1852. Subsequently he moved to Germany and studied there.

In 1866 he married Princess Helena, the third daughter of Queen Victoria. One of the conditions of the marriage was that the couple should live in England, and they spent most of their married life in Windsor. Prince Christian became a Knight of the Garter and a General in the British army although he never held a field command or staff appointment. However, their eldest son, Prince Christian Victor, saw active service in the British army in the Sudan and Ghana, and died in South Africa of enteric fever in 1900 during the Anglo-Boer War.

Prince Christian died in 1917 and is buried in the royal burial ground at Frogmore in Windsor Great Park. Princess Helena, who was a popular member of the British royal family, died in 1923 and is also buried at Frogmore.

94.K.
BEAGLES POSTCARDS

H.H. PRINCE CHRISTIAN
OF SCHLESWIG-HOLSTEIN.

PHOTO
RUSSELL & SONS.
WINDSOR.

Leopold IV, Prince of Lippe (1871–1949, reigned 1905–1918)

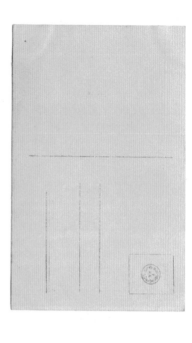

Lippe was a small German princely state situated between Hanover and Wesphalia. Although Leopold only became the ruling prince in 1905, he had been acting as regent throughout the previous decade.

In 1911 Leopold survived an attack by a group of Italian labourers. During the First World War he upgraded the titles of a number of members of the House of Lippe. However, along with the other ruling German princes, he lost his throne in the revolution of November 1918.

During the interwar period all three of his sons by his first wife (two of whom are pictured here) joined the Nazi Party, and were subsequently disinherited by the Prince. His son by his second wife thus succeeded him when he died. His nephew, Count Bernhard of Lippe-Biesterfeld, later became Prince Consort to Queen Juliana of the Netherlands.

Fürst Leopold zur Lippe im Kreise seiner Familie.

47

48

The Princess of Schaumburg-Lippe

This ornate card, which dates from before the First World War, is of one of the princesses of Schaumburg-Lippe, a small German state, which was situated within the present-day state of Lower Saxony.

Schaumburg-Lippe became a princely state in 1807. The last ruling prince was Adolf II (1883–1936, reigned 1911–18), who abdicated in November 1918 following the revolution in Germany at the end of the First World War.

Gruß aus Bonn

Isn't this a lovely card, and proves my patriotic & military feeling? I fear only I am too tall for an Husar – Then, perhaps, I am going to Berlin zur Garde, die unser Kaiser Wilhelm liebt... But I think it is much prettier: zu blasen die blauen Husaren "Und reiten zum Thore hinaus – Yr soldier in spe A. Hoffmann

P.S. Colin and am 19. u. 20 geboren Merry greetings, Jonny Sachsenhaus Stollberg /

Die Prinzessin von Lippe!

Sachsenhaus, Godesberg.

Prince Ernst August, Duke of Braunschweig and Lüneburg (1887–1953, ruled 1913–1918)

Prince Ernst August was the third son of the last Crown Prince of Hanover, Ernst August, Duke of Cumberland. In 1913 he married Viktoria Luise, the daughter of Kaiser Wilhelm II. This marriage ended a decades-old rift between the houses of Hohenzollern and Hanover and as part of the settlement Ernst August was appointed ruling Duke of Braunschweig and Lüneburg. Hanover, however, remained a province of Prussia, as it had been since the Franco-Prussian War and the establishment of the German Empire under the rule of the Hohenzollerns.

Ernst August served in the army during the First World War, but in October 1918 he was forced to abdicate and went into exile in Austria, where he lived at Cumberland Castle, Gmunden. He spent most of the interwar years trying to obtain restitution from successive German governments. In 1945, when the Soviet army entered Austria, he was again forced to flee, and he spent his last years in Hanover. He was the last ruling monarch of the house of Hanover.

4569

Copyright 1913. printed in Germany.

SANDAU

Prinz Ernst August
Herzog zu Braunschweig und Lüneburg.

51

Prince Maximilian Alexander Friedrich Wilhelm of Baden (1867–1929)

Prince Max of Baden was the cousin and heir of Grand Duke Frederick II of Baden, and succeeded him as head of the Grand Ducal house in 1928.

Known as a liberal in politics, he served as President of the First Chamber of the Baden Diet from 1907 to 1918. During the First World War he worked mainly on improving the conditions of prisoners of war of all nationalities, and built up a reputation as a moderate, opposed to the increasingly right-wing policies of the German government. In October 1918 he was appointed Imperial Chancellor, in the hope that he could negotiate an armistice with the Allies, and, for the first time, he brought members of the Social Democratic Party into the government. Failing to persuade the Kaiser of the need to abdicate, he announced the abdication anyway and then resigned in favour of the Social Democrat Friedrich Ebert.

He spent the remainder of his life in retirement, living mostly in Karlsruhe.

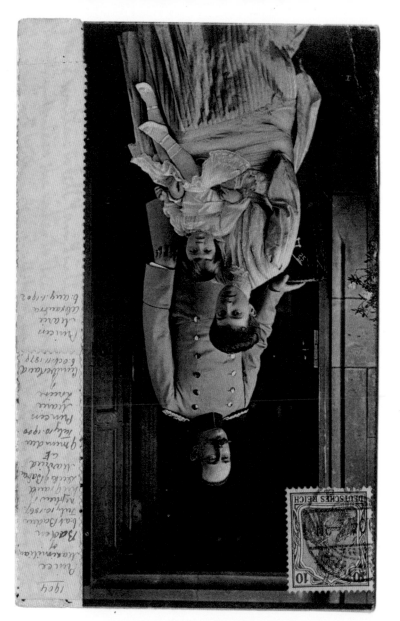

William of Wied, Prince of Albania (1876–1945, reigned March–September 1914)

William of Wied was a member of a minor German princely house, who briefly became Prince (or, in Albanian style, King) of Albania. His early career was in the Prussian cavalry and in 1911 he became a Captain on the German General Staff. However, his aunt, Queen Elisabeth of Romania, on learning that the Great Powers were seeking a candidate to become King of Albania following that country's independence in 1911, actively lobbied on his behalf, and he was eventually offered the throne in 1913.

William's rule was brief, lasting only from March to September 1914, a period characterized by plots, revolts, and civil war. The Greeks occupied the south of the country and on the outbreak of the First World War

William lost his subsidies from Austria when he declared Albania neutral. In September 1914 he fled, initially to Italy, but he subsequently moved to Germany and rejoined the army under the pseudonym 'Count of Kruja'. When German and Austrian troops occupied the Balkans during the course of the war, he hoped to be reinstated as Prince, but nothing came of this, and at the Paris Peace Conference in 1919 the Allies had little sympathy for a German prince who had fought against them. However, William never renounced the throne, even after Albania was officially declared a republic in 1925.

He died in 1945 in Romania and is buried in the Lutheran Church in Bucharest.

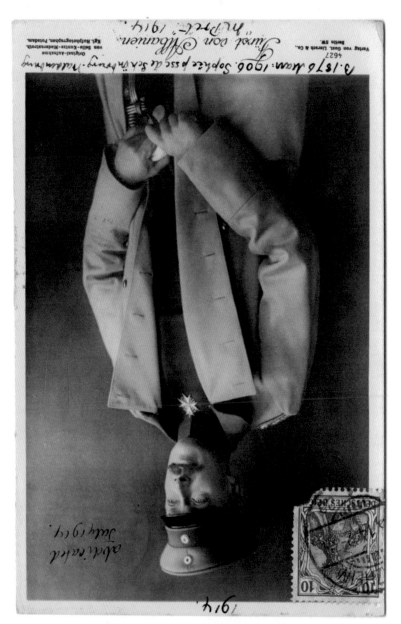

Archduke Franz Ferdinand of Austria (1863–1914)

At the time of his birth Franz Ferdinand was not in line to inherit the Habsburg Empire from his uncle, the Emperor Franz Joseph, but following the suicide of Crown Prince Rudolph at Mayerling, and his own father's renunciation of the throne, Franz Ferdinand was declared heir presumptive in 1889. In 1900, against the wishes of the Emperor, he married Sophie Chotek. The marriage was a morganatic one and his wife was only created Duchess of Hohenburg, meaning that at state functions she was forced to stand far away from her husband in line of precedence.

Franz Ferdinand advocated greater autonomy for the peoples of the Habsburg Empire who had been left out of the Austro-Hungarian Compromise of 1867, including the Czechs and the Croatians. This made him unpopular in Hungary. He also advocated the modernization of the army and naval expansion to ensure Austria-Hungary remained one of the Great Powers.

Franz Ferdinand's assassination by Serb nationalists in Sarajevo on 28 June 1914 triggered the First World War. The Habsburg Empire survived only another four years until it broke up at the end of the war.

Seine K. und K. Hoheit
Herr Erzherzog Franz Ferdinand
mit höchstdessen Familie.

57

Karl I, Emperor of Austria-Hungary (1887–1922, reigned 1916–1918)

Karl, the last monarch of the Habsburg dynasty, succeeded his great uncle Franz Joseph as Emperor of Austria and King of Hungary in 1916 at the height of the First World War. In 1917 he entered into secret peace negotiations with the Allies, which, when they became known, angered his German ally and led to Austria-Hungary becoming an even more subordinate member of the Central Powers. Later, as the tide of war moved against Austria, he sought to save the monarchy by proposing the creation of a confederation in which each

national group would be granted autonomy in its internal affairs. However, by this time most of the national groups wanted nothing less than complete independence and the dual monarchy fell apart. On 11 November 1918 Karl relinquished his participation in the administration of the state but was careful not to abdicate formally. He then fled to Switzerland.

During the 1920s Karl made two abortive attempts to regain the throne of Hungary. After the failure of the second one he left Hungary on a British gunboat that was stationed on the Danube, and was subsequently exiled to Madeira, where he died in some poverty.

In this postcard Karl is pictured with his son, Otto (b.1912). Otto von Habsburg renounced all claims to the Austrian throne in 1961. A consistent advocate of a unified Europe, he served as a member of the European Parliament from 1979 to 1999 and was President of the International Paneuropean Union from 1986 to 2004. He is a citizen of Germany, Austria, Hungary, and Croatia.

S. M. Kaiser Carl I.
mit dem Kronprinzen Otto

6070

Atelier d'Ora, Wien

NPG

59

Alfonso XIII, King of Spain (1886–1941, reigned 1886–1931)

Alfonso's father, Alfonso XII, died aged only twenty-eight in 1885, and Alfonso XIII, born posthumously, became King at birth. There was a regency until 1902, when his accession was marked by a week of festivities throughout Spain.

The early years of Alfonso's rule saw Spain experience mixed fortunes. The country lost its remaining American colonies following the Spanish–American War, but succeeded in remaining neutral during the First World War. The King was keen to encourage tourism and it was in his reign that the network of hotels in historic buildings known as paradors was first established. A keen supporter of football, the King gave his patronage to several important football clubs, including Real Madrid.

During the interwar period the breakdown of the parliamentary system and the dictatorship of General Primo de Rivera, with which the King was associated, led to increasing political and social unrest. In April 1931 a Spanish Republic was proclaimed, upon which the King fled into exile, without, however, formally abdicating the throne.

During the Spanish Civil War the King expressed his support for Franco's Nationalists, but Franco had no intention of restoring the monarchy. Alfonso died in Rome in 1941. Following Franco's death in 1975, Alfonso's grandson, Juan Carlos I was restored to the Spanish throne, and successfully oversaw the restoration of democracy in Spain.

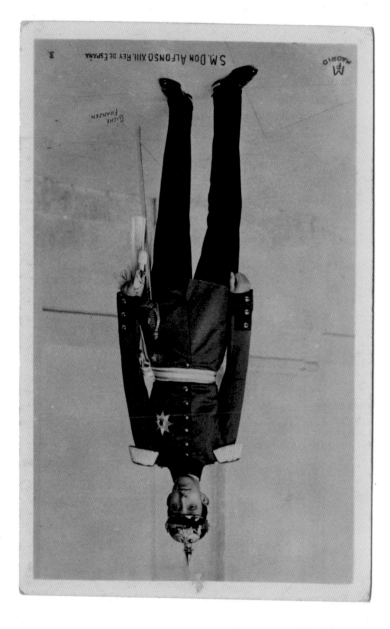

S.M. DON ALFONSO XIII. REY DE ESPAÑA.

MADRID

CLICHÉ FRANZEN.

Umberto II, King of Italy (1904–1983, reigned May–June 1946)

The last King of Italy, Umberto II reigned for only thirty-three days in 1946, before the monarchy was abolished following a referendum. This was no reflection on Umberto himself, who was widely praised for the way in which he had carried out his constitutional duties since he had become Lieutenant General of the Realm, or regent, in 1943, following the overthrow of Mussolini. However, the monarchy was fatally tarnished by its association with Mussolini's Fascist regime and by the failure of Umberto's father, Victor Emmanuel III, to abdicate until it was too late, despite having gone into exile in Egypt in 1943. It has been suggested that had Umberto become king sooner the referendum result would have gone the other way.

Following the abolition of the monarchy, Umberto went into exile in Portugal, where he lived for the rest of his life. He was forbidden to set foot on Italian soil, but after his death in Geneva, his body was taken back to Italy for burial.

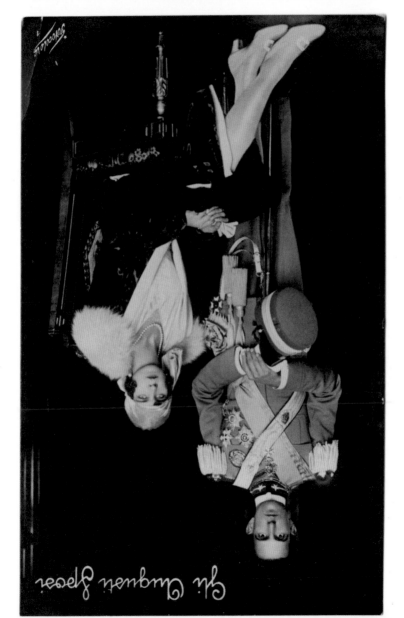

Gli Auguri Ziosa

Constantine II, King of the Hellenes (b.1940, reigned 1964–1974)

Constantine was only one year old when Germany invaded Greece during the Second World War. He returned in 1946, shortly afterwards becoming Crown Prince, and then succeeding his father, Paul, as King in 1964. A keen sportsman, he had won an Olympic gold medal for sailing at the Rome Olympics in 1960.

At the time Constantine became King, Greece was still feeling the effects of the civil war that followed the country's liberation at the end of the Second World War. There was considerable political instability, which culminated in a coup by a group of army colonels in April 1967. Constantine has been much criticized for his acceptance of this coup, thus giving it a degree of legitimacy. In December of the same year he attempted to stage a counter-coup, but this failed and he was forced

to flee the country. Although in exile, he remained technically head of state, until the Colonels abolished the monarchy in 1973.

When the regime of the Colonels was overthrown in 1974, following the botched attempt to unite Cyprus with Greece (Enosis), Constantine confidently expected to be recalled to the throne. However, in December that year in a referendum the Greek people voted decisively in favour of the permanent abolition of the monarchy.

Constantine has made several return visits to Greece but he no longer holds a Greek passport as he refuses to adopt a surname. He now lives in Hampstead, and is a godfather to Prince William.

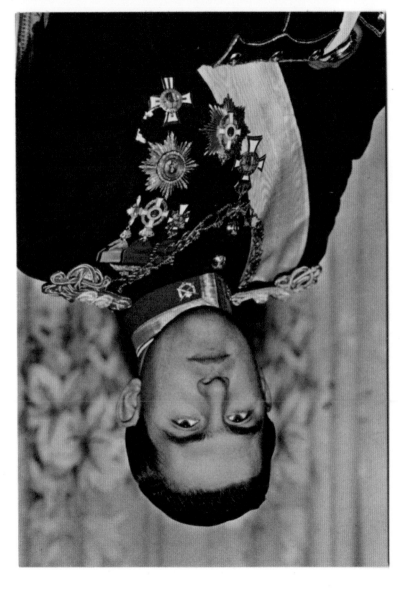

Manoel II, King of Portugal (1889–1932, reigned 1908–1910)

Verlag Percy Hein, München.

Manoel II was the second son of King Carlos I of Portugal. In 1908 there was an assassination attempt on the entire royal family as they drove through Lisbon. The King and his eldest son were killed, but Manoel, although wounded, survived and ascended the throne. However, the political situation in Portugal remained unstable, and in 1910 revolution broke out following the murder of a prominent republican. After three days of fighting, Manoel fled first to Gibraltar and then to England, where he spent the rest of his life. From 1913 onwards, he lived at Fulwell Park, Twickenham, where he became a well-known member of the community,

giving financial support to the local museum, for example. His long residence there is commemorated in the name Manoel Road, and other neighbouring streets also recall the Portuguese connection with the area.

Manoel was a keen tennis player and was a regular visitor to the championships at Wimbledon. It was whilst at Wimbledon in 1932 that he complained of a sore throat, and he died suddenly of tracheal oedema. Following a requiem mass in Westminster Cathedral his body was taken back to Portugal for burial.

König Manuel II. v. Portugal
u. Gemahlin Augusta Viktoria
geb. Prinzessin v. Hohenzollern.

Phot. T. GRAINER
München

Peter I, King of Serbia and subsequently of the Serbs, Croats, and Slovenes (1844–1921, reigned 1903–1921)

Peter was the son of Prince Alexander of Serbia. In 1858 his father abdicated, and Peter spent the remainder of his adolescence in exile. He moved to France and participated in the Franco-Prussian War of 1871. In 1876 he returned to the Balkans and took part in the national wars of liberation against the Ottoman Turks.

In 1903 he returned to Serbia following the removal of King Alexander by a military coup and was crowned King. He attempted to create a constitutional monarchy, and also led Serbia in the Balkan Wars that doubled the size of the country. He then retired, handing over the day-

to-day running of the government to his son, Alexander, but he remained a powerful national symbol, especially during the First World War, when Serbia was overrun by German and Austrian forces. Forced into exile again, he was restored in 1918, and his last public appearance was on 1 December of that year when he was proclaimed King of the newly unified Kingdom of Serbs, Croats, and Slovenes, later known as Yugoslavia.

He remains a popular figure in Serbia and is known as Peter the Liberator.

7119 A KING PETER OF SERVIA. ROTARY PHOTO. E.C.

Nicholas I, Prince and King of Montenegro
(1841–1921, reigned as Prince 1860–1910, as King 1910–1918)

This postcard probably dates from 1910, the year in which Nicholas marked his golden jubilee as ruler of Montenegro and declared himself King. The inclusion of his extended family is significant for Nicholas had pursued a remarkably successful policy of marrying off his children into many other more significant European dynasties, in the hope that these would further his ambitions of creating a South Slav state under his own leadership. As this card shows, he was father-in-law to the King of Italy, two Russian grand dukes, one German princess, and two members of the rival royal houses of Serbia. This gave Montenegro an international importance far greater than its small size would suggest.

Nicholas came to the throne in 1860 following the assassination of his uncle, Danilo II. He proved to

be a successful military leader in the Balkan Wars against the Ottoman Turks and at home ruled under a system of benevolent despotism. In 1914, when Austria attacked Serbia, he was one of the first to come to Serbia's aid. However, his links with the Romanovs were eventually to be his undoing, and when a kingdom of the South Slavs was formed after the First World War, it was the King of Serbia rather than he who was chosen to lead it. Nicholas was forced into exile and lived mainly in France until his death. His body, initially buried in Italy, was repatriated to Montenegro in 1989.

Nicholas was also a poet of some note. He is unquestionably one of the most colourful characters to appear within this volume.

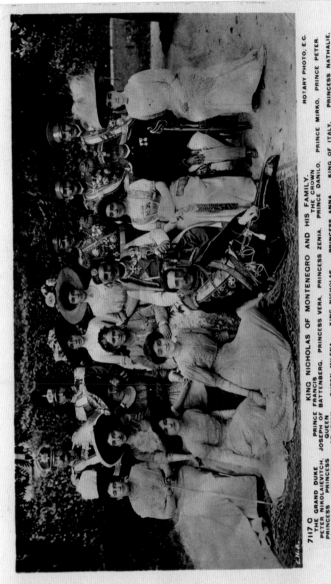

7117 O KING NICHOLAS OF MONTENEGRO AND HIS FAMILY.

THE GRAND DUKE, PRINCE FRANCIS THE CROWN
PETER NIKOLAIEVITCH, JOSEPH OF BATTENBERG, PRINCESS VERA, PRINCESS ZENIA. PRINCE DANILO. PRINCE MIRKO. PRINCE PETER.
PRINCESS PRINCESS QUEEN KING NICHOLAS, PRINCESS ANNA KING OF ITALY. PRINCESS NATHALIE,
MILITZA, MILITZA, OF ITALY. (WIFE OF PRINCE FRANCIS) (WIFE OF PRINCE MIRKO.)
(WIFE OF THE) (WIFE OF DUKE) (JOSEPH OF BATTENBERG)
(GRAND DUKE.) THE CROWN PRINCE ALEXANDER OF SERVIA.
 PRINCESS HELEN OF SERVIA.

ROTARY PHOTO. E.C.

Michael I, King of Romania (b.1921, reigned 1927–1930 and 1940–1947)

In 1927 Michael succeeded his grandfather, King Ferdinand I, as his father had been excluded from the line of succession for eloping with his mistress, Magda Lupescu. However, three years later Carol returned to Romania to regain the crown and Michael reverted to being the Crown Prince. In 1940 the pro-German forces under Marshal Antonescu deposed Carol, and Michael was reinstated as King, although with no political power.

In 1944, as the Second World War turned against the Axis powers, Michael helped to lead the coup that overthrew Antonescu's dictatorship and realigned Romania with the Allied powers. However, Romania fell

within the Soviet sphere of influence and in 1947 Michael was forced to abdicate, allegedly at gunpoint, by the Communist government. Michael went into exile, at first in England and then in Switzerland, where he became a commercial airline pilot.

Following the fall of communism, Michael was permitted to return to Romania, although the immediate post-Communist government of Iliescu was suspicious of his popularity and banned him from the country again. Since 1997 he has again been allowed to live in the country. Unlike Simeon II of Bulgaria, he has not actively engaged in political life in Romania.

KORUNNÍ PRINC RUMUNSKÝ
MICHAL,
velkovévoda z Alba Julia

Peter II, King of Yugoslavia (1923–1970, reigned 1934–1945)

Peter was educated partly in England, and succeeded to the throne of Yugoslavia in 1934, when his father, Alexander I, was assassinated whilst on a state visit to France. Because of his age, a regency was established under the leadership of Prince Paul.

Paul's government favoured stronger ties with Nazi Germany, whereas Peter and his supporters were opposed to Yugoslavia joining the Tri-Partite Pact. In 1941, with British support, Peter participated in a coup which removed Paul's government and tied Yugoslavia to the Allied cause. However, the ensuing German invasion

forced Peter to flee and set up a government in exile in England. During his period of exile he also found time to study at Cambridge University.

The victors in Yugoslavia at the end of the Second World War were Tito's Communist partisans, and before Peter could return to the country the Communist Constituent Assembly deposed him in November 1945. He moved to the United States and died in Los Angeles in 1970. He is buried at the St Sava Serbian Orthodox Monastery in Libertyville, Illinois, although his son has indicated that he wishes his father's body to be reburied in Serbia.

KRALJ. DVOR.
FOTO-ATELJE

RONAY
BEOGRAD.

Њ. В. КРАЉ ПЕТАР II.
NJ. V. KRALJ PETAR II.

Simeon II, Tsar of Bulgaria (b.1937, reigned 1943–1946)

Simeon II is unique amongst the former rulers depicted in this volume in having subsequently served as the democratically elected prime minister of his country.

The son of Tsar Boris III, Simeon was only six when his father died and he ascended to the throne. During the Second World War Bulgaria was allied to Nazi Germany, and in 1944 the Soviet army invaded the country and deposed the royalist government. The monarchy was officially abolished following a plebiscite in 1946 and the royal family went into exile.

Simeon never officially renounced the throne. He pursued a business career in Spain, and returned to

Bulgaria in 1996, six years after the fall of communism. In 2001 he founded a new political party, the National Movement Simeon II, which won 42.7 per cent of the vote in the 2001 elections. Simeon formed a coalition government with the Movement for Rights and Freedoms and served as prime minister from 2001 to 2005. However, the party lost the subsequent election in 2005, receiving only 21.5 per cent of the vote.

In 2007 the party was renamed the National Movement for Stability and Progress, a member of the Liberal International. In Bulgaria Simeon is called Simeon Sakskoburggotski, the Bulgarian form of the German name of the ruling house, Saxe-Coburg-Gotha.

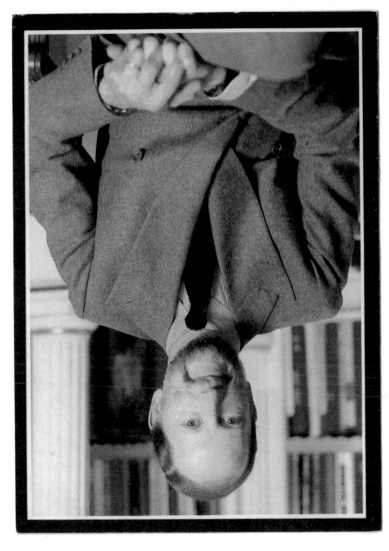

Farouk I, King of Egypt (1920–1965, reigned 1936–1952)

The great-great-grandson of Muhammad Ali Pasha, Farouk succeeded his father, Fuad I, as King of Egypt in 1936, aged just sixteen. Initially popular, Farouk's increasingly extravagant lifestyle later alienated him from the majority of his subjects.

Farouk's government was hampered by corruption and internal rivalries, as well as by the control the British exercised over the country, especially during the Second World War. The Egyptian defeat in the Arab–Israeli War

of 1948 further alienated the military, and Farouk was deposed by a military coup led by Naguib and Nasser in 1952. Although his infant son was proclaimed Fuad II in effect this was the end of the monarchy, which was formally abolished the following year.

Farouk went into exile in Monaco, where he continued to live extravagantly and hedonistically. In 1965 he collapsed and died whilst enjoying a characteristically large meal at a restaurant in Rome.

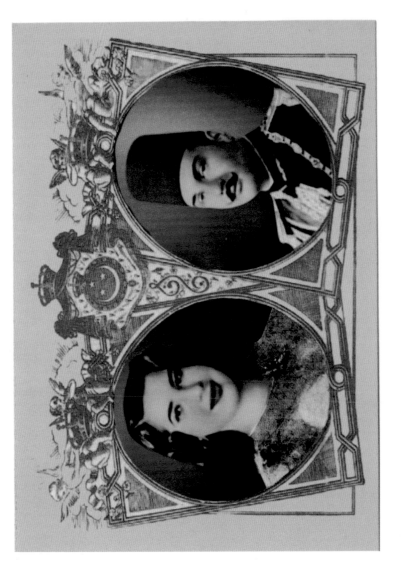

Mohammad Reza Shah Pahlavi, Shah of Iran (1919–1980, reigned 1941–1979)

The Shah of Iran came to the throne when his father, Reza Shah Pahlavi, was forced to abdicate by the British during the Second World War to prevent Iran forming an alliance with Germany.

The early years of his rule were characterized by a power struggle with the prime minister, Mossadeq, who nearly succeeded in deposing him in 1953. However, British and American intervention removed Mossadeq and enabled the Shah to rule as an autocratic monarch.

The Shah followed a consistently pro-Western policy and did much to modernize his country, although this also served to alienate the Shi'ite clergy. He was deposed in the Iranian Revolution of 1979. After brief periods of exile in the United States and Panama, he moved to Cairo where he died and was buried. His tomb is close to that of his brother-in-law, and fellow deposed monarch, King Farouk.

Duleep Singh, Maharaja of Lahore and King of the Sikh Empire (1838–1893, reigned 1843–1849)

Queen Victoria's favourite maharaja, Duleep Singh was the younger son of Ranjit Singh, the 'Lion of the Punjab', and came to the throne in 1843 when he succeeded his half-brother Sher Singh.

Following the Second Anglo-Sikh War and the British annexation of the Punjab in 1849, Duleep Singh was deposed. After spending some time in Fatehgarh and Lucknow, when he converted to Christianity, he was exiled to England in 1854, where he soon became a favourite of Queen Victoria and Prince Albert, who treated him almost as an adopted son. Duleep Singh presented the famed Koh-i-Noor diamond to the Queen.

For most of the rest of his life the Maharaja led the life of an English country squire, eventually settling at Elveden Hall in Norfolk. He considered recovering to Sikhism, and in 1886 attempted to return to India, only to be turned back at Aden. He also travelled to Russia, but failed in his attempt to gain the Tsar's support for his return to India.

The Maharaja died in Paris in 1893 and is buried in Elveden churchyard. A statue of him was unveiled in nearby Thetford by the Prince of Wales in 1999.

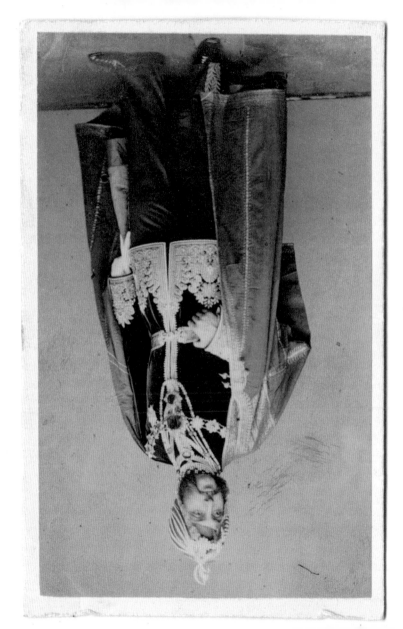

ROTARY PHOTOGRAPHIC SERIES

Printed in Britain.

This is a Real Photograph

POST CARD

The Address only to be Written Here

Ganga Singh, Maharaja of Bikaner (1880–1943, reigned 1887–1943)

Sri Raj Rajeshwar Maharajadhiraj Narendra Maharaja Shiromani Sir Ganga Singh succeeded his brother as Maharaja of Bikaner, a princely state in modern-day Rajasthan, in 1887. He received his military training in the Deoli Regiment and later served as ADC to both the Prince of Wales and the King-Emperor George V. He was the only non-white member of the Imperial War Cabinet during the First World War and subsequently represented India at the Paris Peace Conference in 1919.

At home Ganga Singh had the reputation of being a progressive ruler. His long reign saw the introduction of railways and electricity to Bikaner, as well as extensive irrigation schemes, which greatly increased the state's agricultural productivity. He supported a limited measure of local democracy and established a Representative Assembly in 1913, as well as a council of ministers.

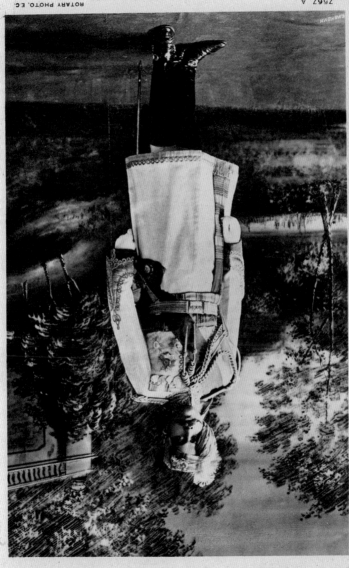

7567 A

ROTARY PHOTO. E.C.

HON. COL. H.H. MAHARAJA OF BIKANER,
(A.D.C. TO THE KING-EMPEROR.)

Digvijaysinhji Ranjitsinhji, Jam of Nawanagar (1895–1966, reigned 1933–1947)

Maharaja Jam Sri Sir Digvijaysinhji Ranjitsinhji Jadega succeeded his uncle, the famous cricketer Ranjitsinhji as Jam of Nawanagar in 1933. He had been educated in both India and the United Kingdom (Malvern College and University College, London), and had subsequently pursued a career in the military, as well as attending meetings of the League of Nations.

Nawanagar, in the present-day Indian state of Gujarat, had the reputation of being one of the best-governed and

liberal of the princely states, with enlightened policies for economic and social development. The Jam was a strong supporter of Indian independence, and Nawanagar was one of the first states to sign the Instrument of Accession following Indian independence in 1947. Jam Digvijaysinhji Ranjitsinhji subsequently became the first Rajpramukh (governor) of Kathiawar. He also served as deputy leader of the Indian delegation to the United Nations.

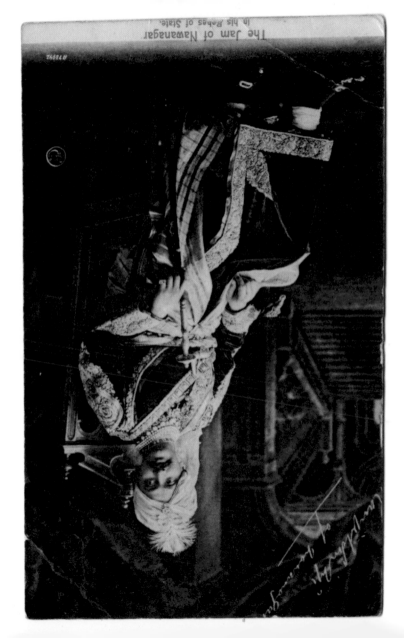

Ito Hirobumi, Resident-General of Korea (1841–1909, ruled 1906–1909)

ROTARY PHOTOGRAPHIC SERIES.

POST CARD.

THE ADDRESS ONLY TO BE
WRITTEN HERE.

Printed
in
England.

Marquess Ito was a Japanese statesman who was educated in both Japan and England. He served four times as Japanese prime minister between 1885 and 1901, and was also responsible for drawing up the Meiji Constitution under which Japan was governed between 1890 and 1945.

Following the Sino-Japanese War of 1894–5, Ito negotiated the treaty under which Korea became independent, although it became recognized that Japan was interested 'in a peculiar degree' in the country.

In November 1905 a special mission, headed by Ito, persuaded the King of Korea to cede control of foreign affairs to a Japanese Resident-General. Ito himself took up this position and then tried to force the King to cede further executive and legislative powers. The King abdicated rather than agree, and was succeeded by his son, Crown Prince Yi, also pictured on this postcard, in a clearly subordinate position. Three years later, Ito was assassinated by Korean nationalists, but Korea remained in all but name a colony of Japan until the end of the Second World War.

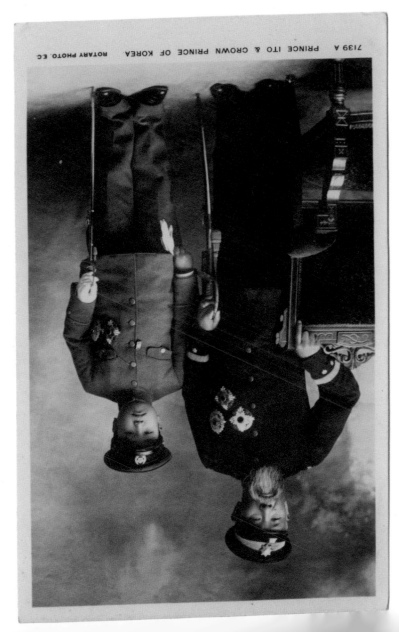

Pu Yi, Emperor of China (1906–1967, reigned 1908–1911)

Often referred to as the 'Last Emperor', Pu Yi was personally selected by the Dowager Empress Cixi, to succeed her. He was only two years old when he ascended the throne and was still only five when he was deposed during the Chinese Revolution of 1911.

Briefly restored for twelve days in 1917, Pu Yi was later expelled from Beijing and went to live in the Japanese concession at Tianjin. When the Japanese overran Manchuria in the early 1930s they installed Pu Yi as the puppet emperor of 'Manchukuo'. Whatever his own intentions may have been, the Japanese were the effective rulers of this supposedly autonomous 'empire', which lasted from 1932 to 1945.

In 1945 Pu Yi was captured by the Soviet army and was handed over to the Chinese Communists. After a period of extensive 're-education,' he was released and was given a job in the Beijing Botanical Gardens. He later worked as a literary editor for the Chinese People's Political Consultative Conference. Pu Yi received some protection from the authorities during the Cultural Revolution, but the strain told on him and he died in 1967.

Pu Yi wrote an important autobiography, and his life was also immortalized in Bertolucci's epic film *The Last Emperor*.

蔡君各種弄術之圖

茲將蔡興和君班中角色首本列左 △ ▽

蔡金彩女士—過山筋斗，華洋小調，天臺耍腰；，．

Kalakaua I, King of Hawaii (1836–1891, reigned 1874–1891)

Known as the 'Merrie Monarch', Kalakaua was fond of music, dancing, parties, and fine food, and during his reign he reintroduced the hula, which had previously been banned, into Hawaii.

The eldest son of High Chief Kahana Kapaakea, Kalakaua is unusual amongst royals for having been elected as King in 1874 by his country's legislature. He had previously stood for election two years earlier but had been defeated by Prince Lunalilo. On Lunalilo's death Kalakaua had to defeat the dowager Queen Emma, and after the election he needed the support of British and American forces to defeat the supporters of the Queen who had refused to accept the election result.

In 1875 Kalakaua travelled to the United States and signed the Reciprocity Treaty, which led to a boom in the Hawaiian sugar industry. However, the King's increasingly lavish lifestyle led to a decline in his support, especially amongst the Europeans and Americans in Hawaii. In 1887 the Hawaiian League, which represented their interests, took control of the government in the Bayonet Revolution and forced through a new constitution that severely restricted the powers of the king. At the same time many native Hawaiian people lost their voting rights, whilst foreigners were for the first time allowed to vote.

Kalakaua died in San Francisco, where he had gone for medical treatment. His last words were supposedly, 'Tell my people I tried.'

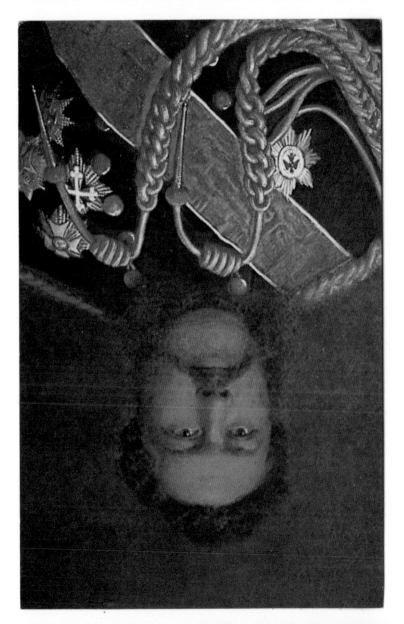

Maximilian I, Emperor of Mexico (1832–1867, reigned 1864–1867)

Emp.re du Mexique

NEURDEIN

Editeur Photographe.

PLACE DE LA BOURSE

8. Rue des Filles S.t Thomas

PARIS

This carte de visite shows Maximilian, an Austrian archduke and brother of the Emperor Franz Joseph, who, with the backing of Napoleon III of France and a group of Mexican conservatives, was prevailed upon to accept the Mexican throne in 1864. Never accepted by many Mexicans, who objected to a foreign ruler being imposed on them, or by other foreign powers such as the United States, his government was never able to enforce its authority throughout the country, and was then fatally weakened by the withdrawal of French troops. Maximilian was captured by revolutionary forces whilst trying to escape from Santiago de Querétaro in 1867, and was subsequently executed by firing squad.

Maximilian's tragedy is the more poignant because he was basically a man of progressive views, who was the victim of Napoleon III's over-ambitious foreign policies. In 1859 he had been dismissed by the Austrian Emperor Franz Joseph from his post as Viceroy of Lombardy-Venetia for being too liberal, and when the Mexican throne was first offered to him he declined it, preferring to go off on a botanical expedition to Brazil.

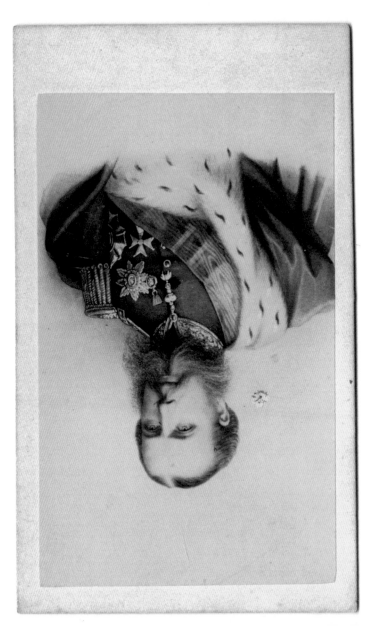